Michelangelo

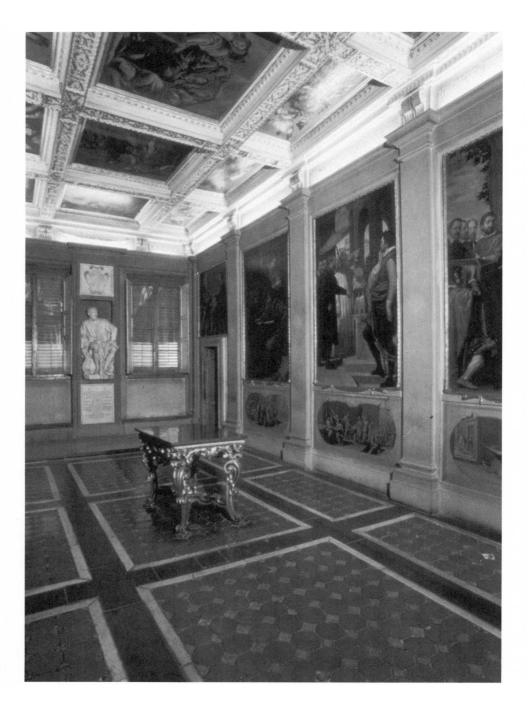

Michelangelo

An Invitation to Casa Buonarroti

Edited by
Pina Ragionieri

CHARTA

Photographic References
Photographic Library
of Casa Buonarroti

Editorial Coordinator
Emanuela Belloni

Design
Gabriele Nason

Editing and Layout
Studio Doni & Associati,
Florence

Press Office
Silvia Palombi Arte & Mostre,
Milan

Technical Production
Amilcare Pizzi Arti grafiche Spa,
Milan

English Translation
Paul Blanchard

Exhibition and catalogue curator
Pina Ragionieri
Director, Ente Casa
Buonarroti, Florence

Exhibition Co-Ordinators
Elisabetta Archi
Roberta Cremoncini

Exhibition Designer
Dante Donegani

Installation
Bourlet-Martin

Insurance
Government Indemnity
Fine Art and Jewellery Division
Jardine Insurance Brokers
International Ltd

Transport
Borghi Trasporti Spedizioni Spa

Michelangelo
an Invitation to Casa Buonarroti
29th April 1994 - 24th July 1994
Accademia Italiana delle Arti
e delle Arti Applicate
24 Rutland Gate, London SW7

Honorary Committee

Beniamino Andreatta
Italian Minister
of Foreign Affairs

Alberto Ronchey
Italian Minister
of Cultural Heritage

Valdo Spini
Italian Minister
of the Environment

Laura Fincato
Minister of State, Italian
Ministry of Cultural Heritage

Giorgio Morales
Mayor of Florence

Giacomo Attolico
Italian Ambassador, London

Ferdinando Salleo
Secretary General, Italian
Ministry of Foreign Affairs

Enrico Pietromarchi
Director General of Cultural
Relations Italian Ministry of
Foreign Affairs

Antonio Armellini
Minister Counsellor, Italian
Embassy, London

Guido Lenzi
Deputy Chef the Cabinet,
Italian Ministry of Foreign
Affairs

Francesco Sisinni
Director General, General
Department B.A.A.A.A.S. ,
Italian Ministry
of Cultural Heritage

Ombretta Pacilio
Italian Ministry
of Foreign Affairs

Michelangelo Pipan
Cultural Counsellor,
Italian Embassy, London

Antonio Paolucci
Superintendent for Artistic
and Historic Heritage
of Florence

Maria Grazia Benini
Italian Ministry of Cultural
Heritage

Luciano Berti
Chairman, Ente Casa
Buonarroti, Florence

D'ANGELI EDITORE

Jardines

Contents

8 Foreword
Rosa Maria Letts

11 An Invitation to Casa Buonarroti
Pina Ragionieri

27 Catalogue

87 Selected Bibliography

*It is with awe and a sense of bewilderment that any art lover,
historian or critic approaches a project which involves the name
of Michelangelo. The attribute of 'divine' and the concept of
'terribilità' are most often associated with his genius.
We have always dreamed of presenting an exhibition at the
Accademia Italiana which would illustrate some aspect of his
art. We could not begin to think what form it should take nor
what aspect one would be able to approach it from.
Suddenly, as has often happened in the life of the Accademia,
an engaging and original project was presented to us. It is
particularly appropriate as it will complement the recent
restoration and unveiling of Michelangelo's apocalyptic fresco
of the* Last Judgement *in the Vatican.
Pina Ragionieri, Director of the Casa Buonarroti in Florence
offered us this elegant and measured exhibition entitled 'An
Invitation to Casa Buonarroti'.
The exhibition is for us a way into Michelangelo's private
world. A part of his world, the most intimate and
unpretentious, reflecting the material taste, modesty and
measure of the man who has left, in contrast, perhaps the most
revolutionary artistic message of the Western world. A message
with no limit for its formal expression nor constraint for its
spiritual content.
As Berni said with regard to a Michelangelo's sonnet:*

'tacete unquanco, pallide viole/e liquidi cristalli e fere snelle./
Ei dice cose, e voi dite parole'.
('Be silent, you pale flowers/liquid crystals and slender
beasts/For he speaks content, and you just words.')

*We may so easily apply these words to Michelangelo's painting
as compared to that of other artists.
Among the drawings chosen for this exhibition by the curators
is the most complete sketch for the* Last Judgement *and*

Abraham and Isaac, *a rarely seen work. Both carry tremendous potency and lead us into Michelangelo's inner tormented spiritual world. In some of the other drawings of fortifications, architectural plans, his letters and even a menu we discover the physical world of the artist, within which he sought shelter.*

The exhibition is also characterised by the fact that it refers mostly to Michelangelo's later years, to works conceived during his maturity when his awareness of his own mortality heightened his religious beliefs:

'mille piacer non vaglion un tormento'.
('a thousand joys do not equal one torment'.)

The exhibition will bring us closer to the poetic world of Michelangelo, preparing us for the torment and terror of the Last Judgement. The first can be further experienced in Casa Buonarroti, the second in the Sistine Chapel.

Here I wish to thank the generosity of the Florentine authorities for allowing us to borrow such treasures and particularly the Soprintendente Antonio Paolucci, and Pina Ragionieri. I also thank the Italian Ministry of Cultural Heritage. We are particularly grateful to the Italian Foreign Office and the Italian Embassy in London, in particular to H.E. Ambassador Giacomo Attolico, for their cooperation and generous sponsorship.

Other sponsors have enabled the event to materialise, and we thank the intelligent, inventive designer Moschino, the D'Angeli publishing group in the person of their Chairman Paolo Alazraki, Jardine Insurance Brokers International Ltd, Cadenza and Italy Sky Shuttle and Italian Escapades.

Rosa Maria Letts

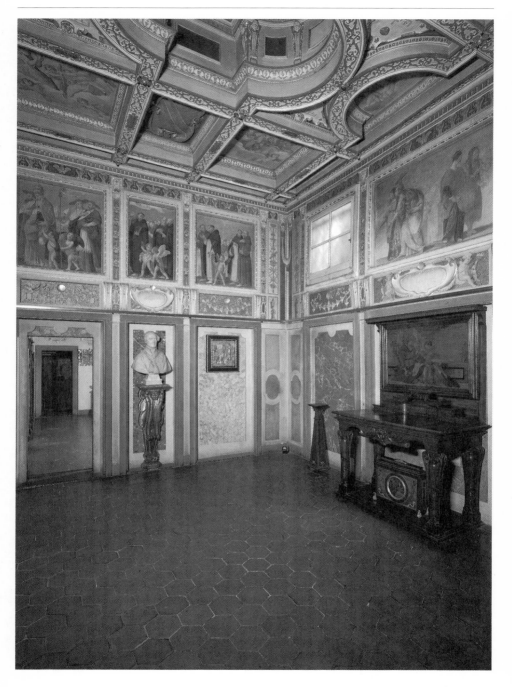

An Invitation to Casa Buonarroti
Pina Ragionieri

Via Ghibellina is a historic street in central Florence lined with time-honored homes and mansions, sometimes unfortunately degraded. In the tract between Via Verdi and the boulevards, at number seventy, stands a noble seventeenth-century mansion whose very name evokes important, profound memories: the Casa Buonarroti. Behind its severe façade dwells an institution eager to fulfill the role that its traditions have imposed upon it locally, nationally, and internationally. It is best known as the Museum containing several of Michelangelo's masterpieces, among which the two symbols of the Casa Buonarroti, the *Madonna of the Stairs* and the *Battle of Centaurs*, executed in Florence when the artist was still an adolescent. The former bears witness to his intense study of Donatello, the latter to his life-long passion for classical art. The Museum also hosts the extensive collections of painting, sculpture, archaeological finds, and majolicas assembled by several generations of the Buonarroti family. Before setting out the special visit-at-a-distance represented by our "invitation," and with a view to making that visit more fruitful, we will do well to acquaint ourselves with other memories and other vicissitudes by tracing the Casa Buonarroti's history from the beginning.

A document discovered by Michelangelo scholar Giovanni Poggi and published in 1965 by Ugo Procacci in his exhaustive catalogue of the Casa Buonarroti shows that, on 3 March 1508, Michelangelo purchased, at the price of 1050 *fiorini larghi*, three houses and a cottage (referred to as a *domuncola*) on Via Ghibellina and Via Santa Maria, now Via Michelangiolo Buonarroti. Another small house, adjoining these, was acquired by the artist in April 1514. Three of the five houses may have been rented out immediately; in the two more spacious ones Michelangelo is known to have lived from 1516 to 1525, when his Medici commissions did not send him

"Room of the Angels", in Casa Buonarroti

11

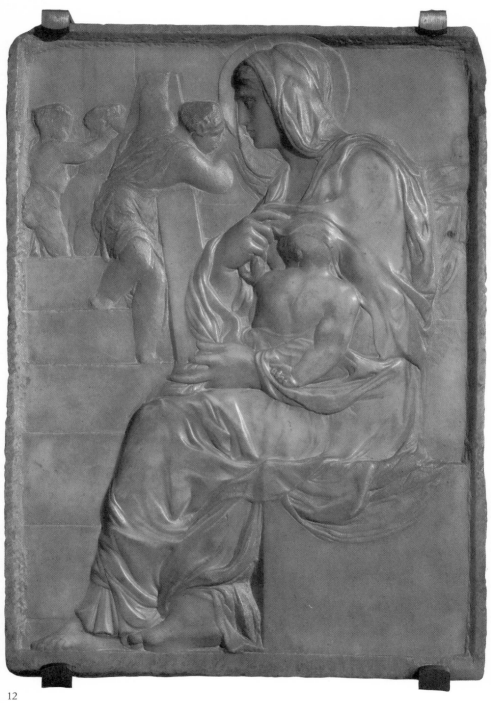

off in search of marble in Carrara or Pietrasanta. In 1525 he moved to the San Lorenzo neighborhood, at the suggestion of Clement VII; and from that year on all five houses were rented.

The houses facing Via Ghibellina were destined to vanish during the first refurbishing undertaken around 1590 by Leonardo Buonarroti (the son of Michelangelo's elder brother, Buonarroto). A second, more organic (as we shall see shortly) renovation was undertaken between 1612 and 1640 by Leonardo's son, Michelangelo Buonarroti the Younger. Still extant but only partially recovered is the third small house (mentioned as a *domuncola* in the bill of sale) to which access may be gained today from Via dell'Agnolo 67 r, where passers-by may pause to admire a narrow doorway with pietra serena doorposts flanking a small rolling shutter. From here a narrow corridor twelve meters long leads to a group of rooms arranged sequentially and only partially restored, due to the chronic lack of funds that afflicts all institutions not only in Italy. The complete recovery of these rooms would be of extraordinary historic importance for the Casa, as the public would once more be able to enjoy the only spaces that have remained intact since Michelangelo bought the buildings in 1508 and 1514.

Mention has been made that the houses were rented out as early as 1525. Although Michelangelo lived elsewhere, a constant, even obsessive preoccupation can be gleaned in his correspondence, especially following his final move to Rome in 1534: to give for all time his family name to a building in Florence, what he himself defined "an honorable home in the city." The only male heir in the family, his nephew Leonardo, escaped his uncle's continuous pressures only by marrying Cassandra Ridolfi in 1553 and agreeing to a renovation limited just to a part of the property. An appreciable result was not

The Buonarroti Home
engraving, 19th century

Michelangelo,
Madonna of the Stairs

13

Michelangelo, *Battle of Centaurs*

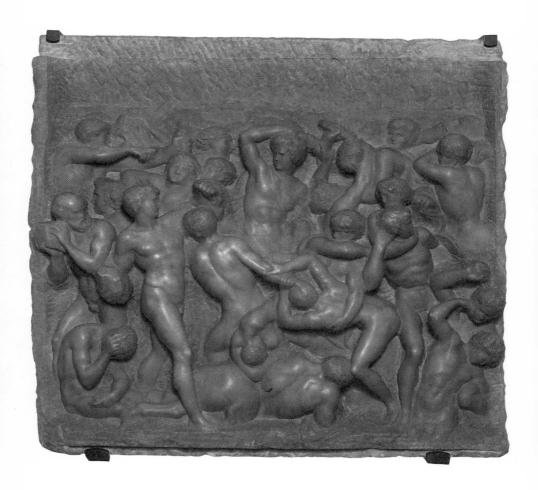

achieved in Michelangelo's lifetime and it was not until 1590 that Leonardo's discontinuous interest came to focus on the family home that his famous uncle had desired for so many years.

The most significant phase in the mansion's development was undoubtedly that undertaken by one of Leonardo's children, Michelangelo Buonarroti the Younger (1568-1647), a leading figure on the cultural scene of Florence during the first half of the seventeenth century, thus far studied more as a man of letters and of the theatre (as the author of *La Tancia* and of *La Fiera*) than for his outstanding quality as a versatile and enterprising cultural organizer, the friend and generous patron of artists. The numerous volumes of his correspondence, administrative papers, and other writings, kept in the Buonarroti archive, if adequately investigated might provide an interesting intellectual portrait of this many-faceted figure.

Michelangelo the Younger enlarged the property and it was at his initiative that the mansion took on its present appearance, inside and out. He is responsible for the monumental rooms, on the first floor of the house, celebrating the glory of his forefather and the greatness of his family: here the Florentine and Tuscan Seicento surely reaches some of its highest summits. The complex decorative programme of the rooms was conceived by Michelangelo the Younger and has come down to us in numerous testimonies, including a comprehensive late-seventeenth-century inventory that proved of fundamental importance to the background research for the new conception of the Museum implemented just a few months ago.

The first room, called the Gallery, was decorated between 1613 and 1635. It presents a eulogy of Michelangelo, accomplished by means of a singular biography in images

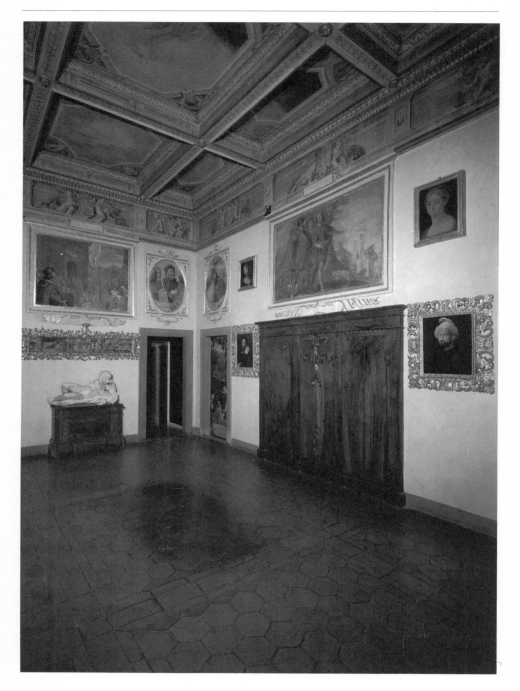

painted by the most important artists working at the time in Florence: Empoli, Passignano, Artemisia Gentileschi, and Giovanni da San Giovanni. Until 1875 the *Battle of Centaurs* (the extraordinary relief that Michelangelo carved in his early adolescence, while he was studying with the sculptor Bertoldo in the San Marco Gardens) was displayed in this room beneath a large panel by Ascanio Condivi, taken from a cartoon by Michelangelo now in the British Museum, but acquired by Michelangelo the Younger, on the Rome market, as an autographic painting of his famous ancestor.

The decoration of the second room, the Room of Night and Day, was begun in 1624 and went on for years. In 1625 Jacopo Vignali painted the ceiling fresco of God the Father Separating Light from Darkness and the personifications of Night and Day whence the room takes its name; the most singular characteristic here is undoubtedly the small Writing Room to which Michelangelo the Younger withdrew to study. The fresco decoration continues on the walls with the representation of family figures. The chamber is also adorned with important art works, notably the *Stories of Saint Nicholas of Bari*, the masterpiece of Giovanni di Francesco, a painter active in Florence in the mid-fifteenth century; the famous portrait of Michelangelo executed by Giuliano Bugiardini; and the bronze head of the artist was by Daniele da Volterra. The sequence continues with the Room of the Angels, used as a chapel after 1666 and bearing mural frescoes by Jacopo Vignali with images of Saints who advance in procession from the militant Church to the triumphant Church. Those who enter the room cannot help but admire, above the altar, the large inlaid wood composition based on a cartoon by Pietro da Cortona and representing the Virgin and Child, datable around 1642. (Some other doors of these rooms, also, contain precious wood inlays following cartoons by this artist, who

Giovanni di Francesco, *Stories of Saint Nicholas of Bari*, detail

"Room of Night and Day", in Casa Buonarroti

17

was a friend of Casa Buonarroti's owner and his guest while working at the Pitti Palace). In the same room a famous marble bust by Giuliano Finelli portrays Michelangelo the Younger.

The fourth room, the Study, was decorated between 1633-37. High up on the walls, the portraits of illustrious Tuscans, painted by Cecco Bravo, Matteo Rosselli, and Domenico Pugliani, form a picturesque sequence of faithfully reproduced, familiar faces. Beneath the frescoes runs a series of wooden wardrobes with ivory and mother-of-pearl inlays, alternating with show cases which evoke different aspects of the family collections. In one show case a terra-cotta model certainly by Michelangelo represents an allegorical group, the subject of which has been interpreted in a variety of ways by the critics.

These four rooms, followed by a small room where Michelangelo the Younger fondly kept many pieces from his collections, have remained miraculously intact (they are the only rooms of the mansion to have had this luck) despite the many changes and the sometimes extensive renovations that the home underwent during the course of time. For instance, in an early-nineteenth-century action another contribution of Michelangelo the Younger - a sort of hanging garden of delights situated on the attic porch and including a grotto with stuccoes, artificial sponges, and water devices - was almost entirely lost. All that remains is one room, adjoining the still extant roof-terrace and carefully restored in 1964, but unfortunately difficult to reach and hence not included in the itinerary for museum visitors. Its ceiling was frescoed in 1638 by Giovan Battista Cartei with a pleasantly decorative pergola with birds.

Two fundamental characteristics of Michelangelo the Younger, his passion for collecting and his cult of family

heirlooms, underlie the formation of the family's artistic heritage. It was he who acquired family portraits and antique sculpture; he who chose to place the *Battle of Centaurs* in a pre-eminent position in the first of the monumental rooms; he who contracted with the sacristan of Santa Croce to acquire the predella with the *Stories of Saint Nicholas*; and to him the Casa Buonarroti owes the recovery of the *Madonna of the Stairs* and a large number of Michelangelo's drawings.

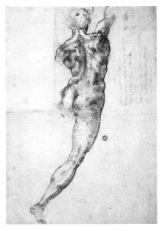

Michelangelo,
A Male Figure seen from behind

Here we will do well to pause a moment, going back in time to explore our subject more thoroughly by speaking of what is perhaps the most valuable collection: Michelangelo's drawings. Vasari's words on the artist's desire for perfection are well known. Before his death in Rome in 1564, Michelangelo wanted to burn "many of the drawings, sketches, and cartoons made by his hand, so that no one should see the difficulties he had and the ways of trying his ingenuity, so as not to appear less than perfect." Fortunately many of Michelangelo's drawings were still in Florence at the time of his death; but his nephew Leonardo, to fulfill the art-collecting wishes of Cosimo I, gave the Medici duke a good number of them, around 1566, together with the *Madonna of the Stairs* and everything else that had remained in the studio on Via Mozza that Michelangelo had left when he made his final move to Rome.

When Michelangelo the Younger devoted a series of rooms in the family home to the memory of his great ancestor, as we have seen, more than fifty years later, the *Madonna of the Stairs* and part of the drawings given to the Medici were returned to him by Cosimo II. Meanwhile the artist's mindful great-nephew set about recovering Michelangelo's autographic drawings at whatever price was necessary, on the Roman market and elsewhere. Many of the drawings were gathered together in

volumes; but the ones that seemed most beautiful were framed and hung on the walls of the new rooms.

The Buonarroti family's collection of drawings was at this time the most outstanding collection of Michelangelo's drawings in the world; and it remains so today, with more than two hundred pieces, notwithstanding the grievous damages it has suffered. Impoverished in the late eighteenth century by a first sale made by the revolutionary Filippo Buonarroti (1761-1837) to the French painter and collector Jean Baptiste Wicar, in October 1858 it suffered another considerable reduction as a consequence of the sale to the British Museum made by Cavalier Michelangelo Buonarroti. The latter sale came just a few months after the death of Cosimo Buonarroti (born 1790), the family's last direct heir and, as such, holder of the lion's share of Michelangelo's papers, which he had ceded in his will to the public enjoyment together with the mansion on Via Ghibellina and the objects it contained. For many years thereafter the valuable drawings remained in frames and show cases. They were saved from such irrational keeping only in 1960. Sent to the Print and Drawing Cabinet of the Uffizi for restoration, they returned to the Casa Buonarroti in 1975. As precise motives of conservation discourage the permanent exhibition of old master drawings, today small selections from the collection are presented on a rotating basis in a room in the Museum possessing the suitable thermohygrometric and lighting conditions.

Now let us return to the history of the family and Casa Buonarroti. In 1704 the complex was assigned to Filippo Buonarroti (1661-1733), President of the Accademia Etrusca of Cortona, member of the Crusca, and an esteemed archaeologist, who enhanced the family collections with

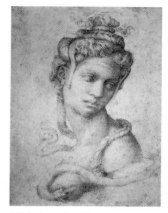

Michelangelo, *Cleopatra*

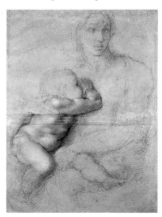

Michelangelo,
Madonna and Child

Etruscan and Roman works, many of which are still displayed in the Museum.

The late eighteenth and early nineteenth centuries represented an especially difficult period for the mansion and for the family. In 1799 the Austrian presidium governing Florence decreed the confiscation of the Buonarroti fortune, and assigned it to the Hospital of Santa Maria Nuova. This decision was reached because the legitimate heir, the same Filippo whom we had seen sell Michelangelo's drawings, a democratic egalitarian who had emigrated to France in 1789, was awaiting deportation to Guiana for having taken part in the Conspiration des Eguales de Babeuf. At the beginning of the nineteenth century, soldiers were quartered in the increasingly degraded mansion .

In 1812 Cosimo Buonarroti, who would later become Minister of Education of the Grand Duchy of Tuscany, finally became the curator and owner of the complex. He undertook major restoration work and returned to live in the Casa, marrying in 1846 the Anglo-Venetian noblewoman Rosina Vendramin (1814-1856), who passionately devoted her energies to the family heirlooms. To her, credit is due, for the transcription of numerous archival documents and the rediscovery of a wax model considered to be a work of Michelangelo.

When Cosimo died in 1858 without leaving direct heirs, the mansion on Via Ghibellina passed to the City of Florence, though not without conflicts with the indirect heirs. The Casa Buonarroti was nevertheless constituted as a charity the following year by Grand Duke Leopoldo II.

The most striking event in the early years of the Authority's administration was the celebration that took place in Florence in 1875 to mark the fourth centennial of Michelangelo's birth. This event, of which the Casa Buonarroti still conserves

considerable archives, had long-lasting repercussions (which in some instances actually began before the centennial year) on the culture and customs of the city: from the construction of Piazzale Michelangelo and the design of the tribune for the *David* at the Accademia, to the publication of Michelangelo's letters by Gaetano Milanesi and an exhibition of Michelangelo's drawings at the Casa Buonarroti. The latter was one of the few projects the Authority succeeded in carrying through to completion, the others being thwarted by financial difficulties. The idea had even been advanced to enrich the façade of the mansion with a complex graffito decoration, for which the plans still exist; but the economic problems became so urgent that many areas of the building had to be rented out as private homes, while in 1881 the collections of antiquities were transferred to the Archaeological Museum. In the early twentieth century the Home hosted the Florentine Museo Storico-topografico. After the First World War it was again broken up and, in part, rented out.

The first modern restorations date from 1951. They were carried out in honor of Giovanni Poggi (1880-1961), the Michelangelo scholar who arranged for numerous works from Florentine galleries to be deposited at the Casa Buonarroti. During these same years the internal set-up of the Museum began to appear antiquated, with certain rooms full of objects arranged without any criteria of quality or content: Michelangelo's masterpieces together with family heirlooms, bits of the Buonarroti collections alongside nineteenth-century mementos. The need was felt to display the collections in a new way, and changes were made that today may seem to have reflected idealistic visions, so to speak, of the facts of art.

In this connection it may be enlightening to examine the

numerous rearrangements of the room in the Museum that still displays the *Battle of Centaurs* and the *Madonna of the Stairs*. Such an examination would pinpoint the numerous uncertainties and difficulties that Museums have encountered in dealing with Michelangelo post-World War II. During the fifties and sixties the room was re-designed; and on the occasion of the Michelangelo centennial of 1964 the entire Casa was subjected to a radical internal restoration, once all the rooms previously rented out had been meritoriously recovered. The wooden beams of the ceiling were brought to light, and new ones were added; rather improbable arches were created in the doorways between one room and another; the second floor of the Casa and the adjacent rooms were renovated - all in keeping with models that were widely accepted in Florence at the time, but that may, in many cases, appear dated today.

Immediately after the centennial the Ente Casa Buonarroti was constituted by State law and Charles De Tolnay, the Princeton professor of Hungarian origin who had recently produced the well-known, monumental monograph on Michelangelo, was appointed as its head.

Tolnay was well aware of the importance of the plurisecular family heirlooms. The improvement of the Museum that he carried out in the late sixties included, for instance, the return from the Florentine Archaeological Museum of a part of the Buonarroti collections, which had been removed some eighty years earlier because they were considered irreconcilable with a complex constituted to glorify the great Michelangelo. And yet, in the fifteen years of Tolnay's management, with the general consensus of Florentine culture, the Casa Buonarroti made every effort to become the "Museum of Michelangelo": while the casts of works by Michelangelo present in the Museum since the 1875

centennial were sent to Caprese (to form a small museum in the artist's birthplace), attention was focused on the figure of the artist by means of acquisitions and new attributions. One of the consequences of the 1964 centennial had been the arrival at the Casa Buonarroti of the Santo Spirito *Crucifix*, attributed to Michelangelo by Margrit Lisner two years earlier and today considered autographic by a great many critics; while from the Accademia delle Arti del Disegno came Michelangelo's only large-scale model, the *River God*, a thrilling work that can now be seen in the Museum alongside the wooden model for the façade of San Lorenzo. There were also other arrivals: the *Venus with Two Small Cupids* from the Palazzina della Meridiana at the Pitti Palace, attributed to Michelangelo (it is now much more credibly assigned to Vincenzo Danti); and an enormous garden statue identified, at the time, with the "fifth slave" for the tomb of Julius II, from the courtyard of the Pitti Palace.

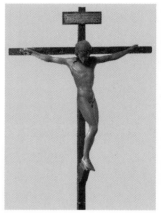

Michelangelo (attr.), *Crucifix*

For years now this unrealistic, univocal approach has been abandoned at the Casa Buonarroti, which has consciously chosen the more practicable road of characterizing itself as the museum of the Casa Buonarroti. This is the direction followed by the overall activity of the Authority, as this house that is not just a museum, but also a place for study and research, a structure that contemplates its history and safeguards its artistic heritage.

In keeping with this principle, those important moments for promoting awareness of the Home's heritage of artworks, historical documents, and heirlooms (the exhibitions now organized on an annual basis) do not refer only to the larger impact of Michelangelo, but place due emphasis on the rich and varied history that I have attempted to outline here.

What has been said so far not only provides an introduction

to this exhibition at the Accademia Italiana in London, but also explains its title. Our choice of works makes it possible to "visit" the old Florentine mansion at a distance, discovering its hidden aspects as well as its apparent ones. The encounter with Michelangelo has been made possible by a selection of his drawings chosen from the Casa Buonarroti collection, whose ups and downs I have briefly narrated; while pages from the Buonarroti Archives give the visitor the excitement of personally observing the artist's handwriting. The image of Michelangelo is offered not only in one of the many portraits that our Museum exhibits, but also in a famous medal by Leone Leoni.

The marble *Madonna of the Stairs* has been mentioned as one of the symbols of the Casa; here the visitor may view the bronze replica that was executed for the family when, a few years after the artist's death, the original went, as we have seen, into the Medici collections, where it remained for several decades.

The original appearance of the *Last Judgment* in the Sistine Chapel may be seen in miniature, made in the workshop of Giulio Clovio, which reproduces the Vatican fresco in the finest detail before its nudes were "trousered."

As for Michelangelo the Younger, the manifold aspects of the figure I have endeavored to characterize in these pages are represented by works of ancient art, family portraits, gifts from artist-friends, and an antique printed volume of his theatrical works.

Nor does our exhibition lack examples of the Casa Buonarroti's archaeological collections, largely assembled, as I have said, by the antiquarian and erudite, Filippo.

In all these things, whoever accepts this special "invitation" to the Casa Buonarroti will savor, we truly hope, the same atmosphere, sensations, and aesthetic emotions as those who walk through the doorway on Via Ghibellina in Florence.

Special thanks are owed to Giovanni Agosti and Luciano Berti, who offered their friendly, valuable, and constant support both to the catalogue and the exhibition.
Acknowledgment is due also to Antonio Paolucci, Superintendent for Artistic and Historic Heritage of Florence; and to Sergio Boni, Elena Lombardi, Agnese Parronchi, Pasquale Sassu, and Sergio Trallori; as well as to Rosa Maria Letts, Roberta Cremoncini, and all friends at the Accademia Italiana.

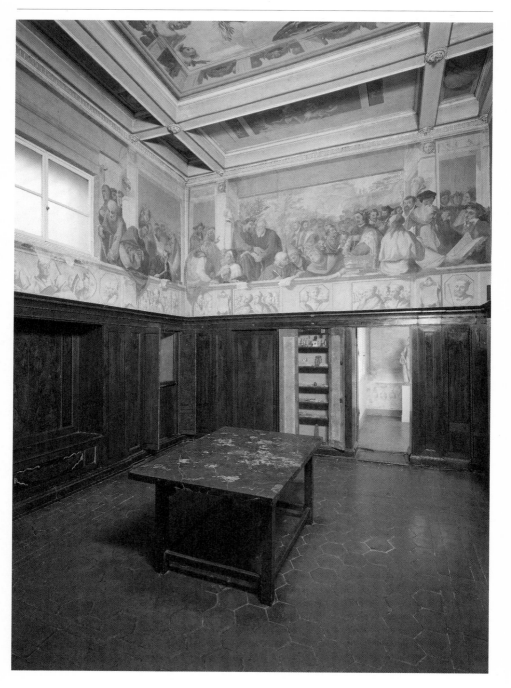

Catalogue

1. Cafaggiolo Manufactury
Plate with the Buonarroti Coat of Arms
mid-sixteenth century
majolica, ø 27.7 cm.
inv. 79

At the center of this plate are the Buonarroti family arms, which include the emblems of Pope Leo X granted to Michelangelo's brother, Buonarroto Buonarroti, when he was appointed prior in 1515. On that occasion the pope decided that priors in office could use the blue Medici ball with the French fleur-de-lis and the letters "L.P.X." (Leo Papa X) in their family emblems; the Buonarroti arms incorporated these attributes from that moment on. The episode is represented in a fresco by Pietro da Cortona in the seventeenth-century rooms of the Casa Buonarroti.

The plate was made in the celebrated majolica workshop of Cafaggiolo in the Mugello, near Florence, a manufactory established in the Medici castle of the same name in the late fifteenth century. On the back is the faded mark, "SPR," which distinguished the Cafaggiolo output for roughly a century.

Bibliography: Alessandro Alinari, in *Ceramica toscana dal Medioevo al XVIII secolo,* exhibition catalogue edited by Gian Carlo Boiani, Rome 1990, pp. 159-160.

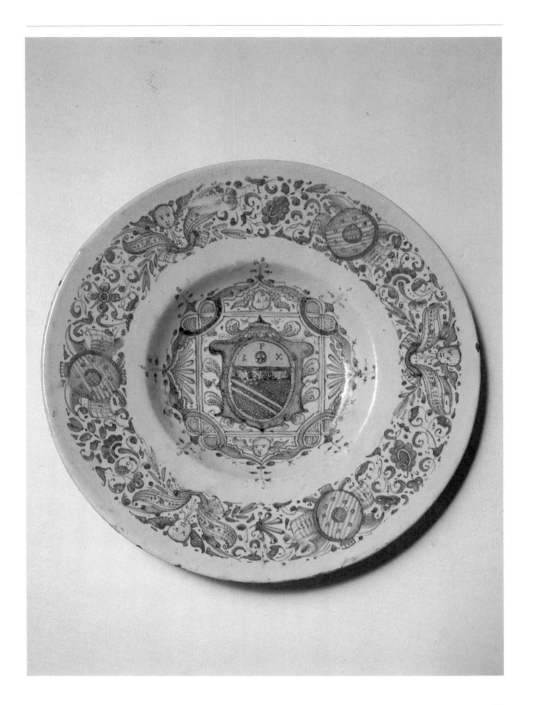

2. Attributed to Marcello Venusti
(Como 1512/15 - Rome 1579)
Portrait of Michelangelo
after 1535
canvas, 36 × 27 cm.
inv. 188

Many portraits of Michelangelo hang in the Casa
Buonarroti, to which they came on deposit from
the Florentine Galleries during the first half of the
twentieth century. All derive from a single
prototype, the famous portrait of the artist
executed in Rome, around 1535, by the Florentine
Jacopino del Conte (1510-1598).

The portrait exhibited here, traditionally attributed
to Venusti, derives from the same prototype but
has been in the Buonarroti family collections for
centuries: it is mentioned in an inventory of 1799,
which also specifies its location in the seventeenth-
century rooms on the first floor of the mansion.

The magnificent baroque frame, a work of
seventeenth-century Florentine craftsmanship, is
worthy of mention.

Bibliography: Ernst Steinmann, *Die Portrait-
darstellungen des Michelangelo,* Leipzig 1913,
pp. 31-32; Ugo Procacci, *La Casa Buonarroti a
Firenze,* Milan 1965, pp. 193-194.

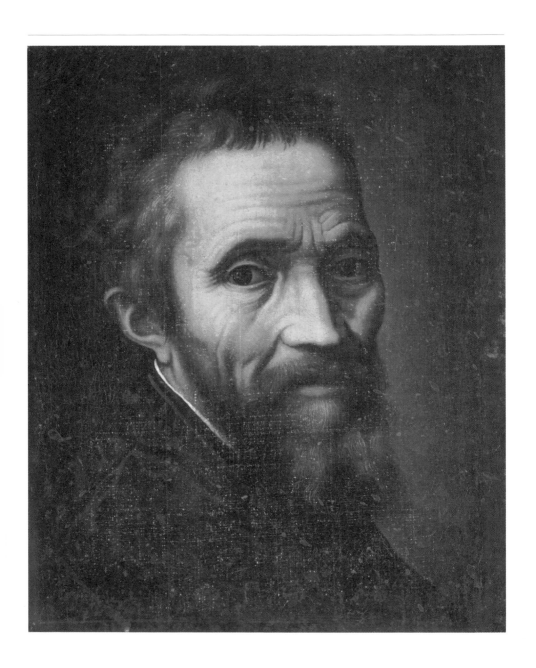

3. Leone Leoni
(Menaggio 1509 - Milan 1590)
Medal of Michelangelo
1561
lead, ø 63 mm.
inv. 611

The *recto* of this medal bears a bust of Michelangelo viewed in profile from the right. The words "MICHELANGELUS BONARROTUS FLOR (entinus) AET(atis) S(uae) ANN(is) 88" appear around the edge. The indication of the age is clearly wrong, as Michelangelo was born in 1475. At the base of the bust is the artist's signature ("LEO"). On the *verso* appears an elderly blind man with Michelangelo's features, led by a dog. The legend around the edge, DOCEBO INIQUOS V(ias) T(uas) ET IMPII AD TE CONVER(tentur)," is taken from *Psalms*, 51:15. This famous, beautiful medal was made in Milan in 1561, as a letter by its author to Michelangelo, dated 14 March of that year and sent along with four specimens of the work (two in silver and two in bronze), demonstrates. The medal was extolled a few years later by Vasari, in his *Life of Michelangelo,* with these words: "And at that time the Cavalier Lione portrayed Michelagnolo in a medal very vivaciously, and to his pleasure made him on the back a blind man led by a dog ... and because he liked it well, Michelagnolo gave him a wax model of a Hercules and Anteus, in his own hand, and several of his drawings."

Bibliography: J. Graham Pollard, *Medaglie italiane del Rinascimento nel Museo Nazionale del Bargello,* III, Florence 1985, pp. 1234-1236, no. 719.

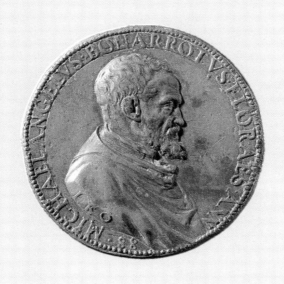

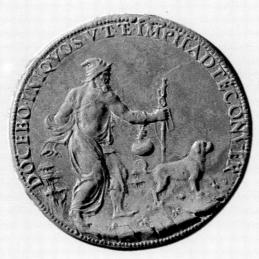

33

4. Sixteenth-century artist
Madonna of the Stairs (after Michelangelo)
circa 1566
bronze, 57 × 40 cm.
inv. 531

This bronze relief reproduces Michelangelo's marble *Madonna of the Stairs,* one of the masterpieces kept at the Casa Buonarroti. This sculpture, made by the adolescent artist around 1490, remained in the house on Via Ghibellina until Michelangelo's nephew Leonardo, after the death of his uncle and before 1568, gave it as a gift to Duke Cosimo I dei Medici. The bronze casting was in all likelihood made on that occasion. The oldest evidence of the work dates from the late seventeenth century when, in the inventory known as the "Descrizione Buonarrotiana," it is mentioned as occupying a niche in the Room of the Angels, where it has recently been placed once more. The same room hosted Michelangelo's marble relief, after Cosimo II returned it to Michelangelo Buonarroti the Younger (1616). The relief, which still bears its original frame, has erroneously but traditionally been attributed to Giambologna. It has recently been ascribed - but this proposal also appears unconvincing - to Vincenzo Danti.

Bibliografia: Hellmut Wohl, "Two Cinquecento Puzzles," in *Antichità viva,* XXX, 1991, no. 6, pp. 42-48.

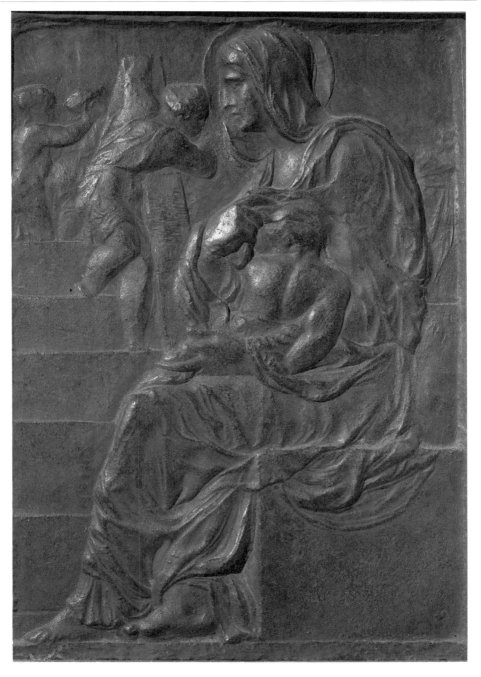

5. Circle of Giulio Clovio
(Grizane 1498 - Rome 1578)
Last Judgment (after Michelangelo)
circa 1570
parchment, 32 × 33 cm.
inv. Gallerie 1890, no. 810

The oldest mention of this miniature found thus far dates from 1800, when the Director of the Uffizi Gallery, Tommaso Puccini, obtained the work from the Royal Wardrobe. That it was in the Medici collections at one time is highly probable.

The parchment represents the *Last Judgment* of the Sistine Chapel, with its 391 figures, before the famous acts of censorship to which it was subjected. All the original nudes are visible, including the group that created the greatest scandal - Saint Blaise, brushes in hand, observing Saint Catherine on the wheel of her martyrdom (at the extreme right, in the middle of the composition) - a group that was not only "trousered," but actually painted over by Daniele da Volterra in 1565.

The miniature is almost identical to the engraving made from the *Judgment* in 1569 by the Dalmatian Martino Rota. The small variations are nevertheless significant: for instance, Christ regains his beard, the absence of which in the fresco had been harshly criticized. At the top of the miniature, where a portrait of Michelangelo appears in Rota's print, God and the Holy Spirit have been inserted, in keeping with the precepts of the Counter Reformation.

The work's stylistic characteristics point in the direction of Giulio Clovio, the most important miniaturist of the Cinquecento.

Bibliography: Giovanni Agosti, "Un Giudizio universale in miniatura," in *Annali della Scuola Normale Superiore di Pisa,* s. III, XIX, 4, 1989, pp. 1291-1297.

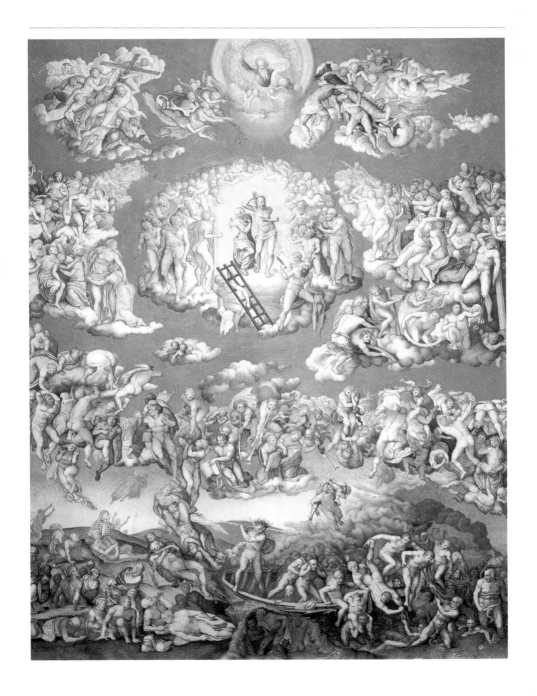

6. Sixteenth-century Florentine school
Portrait of a Lady
(Cassandra Ridolfi Buonarroti?)
panel, ø 19 cm.
inv. 121

The first certain mention of this painting dates from an inventory of 1859, according to which the figure represented is Sestilia Buonarroti, the niece of Michelangelo the Younger who died in 1684 - an idea belied by the clear sixteenth-century character of the work. Ugo Procacci has advanced the hypothesis that this may be a portrait of Cassandra Ridolfi, wife of Leonardo, Michelangelo's much-loved nephew.

Bibliography: Ugo Procacci, *La Casa Buonarroti a Firenze,* Milan 1965, p. 196.

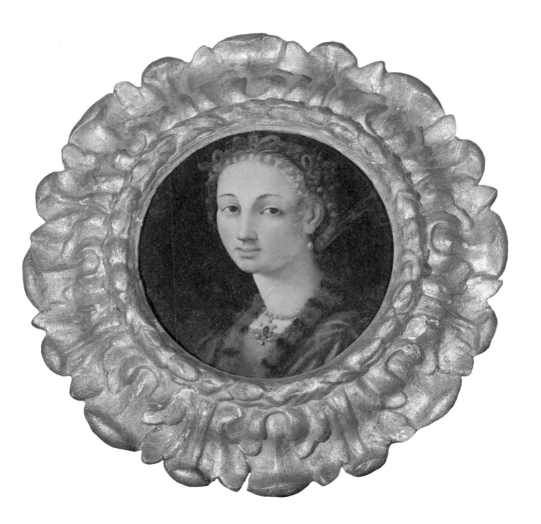

7. Michelangelo Buonarroti the Younger
(Florence 1568-1647)
La Fiera and La Tancia
Tartini e Franchi, Florence 1726
printed volume, 33 × 24 × 4.7 cm.
Library of the Casa Buonarroti, inv. B 1585
a.R.G.F.

This eighteenth-century volume is present in the exhibition not only so that one may admire its wonderful title page representing an allegory of the City of Florence, but also to recall, tangibly, the image and memory of that person among Michelangelo's direct descendents who worked more than any other to exalt the family heirlooms and the glory of his great ancestor in the Casa Buonarroti.

Michelangelo the Younger, a cultural organizer, refined intellectual and collector, friend of artists and scientists, and assiduous contributor to the Vocabolario della Crusca, is here represented through his two works in his primary capacity as playwright. *La Tancia,* a rustic comedy in verse performed at the Medici court in 1611 and published anonymously the following year, is commonly considered his masterpiece; *La Fiera,* performed in 1619 in its first edition at the "Teatro della Gran Sala degli Uffizi," was instead destined to become a lifetime project: endlessly reworked and expanded, it reached mastodontic proportions, extending over no less than five "giornate" for a total of twenty-five acts. The volume shown here carries the first printed edition, annotated by Antonio Maria Salvini.

Bibliography: Maria Giovanna Masera, *Michelangelo Buonarroti the Younger,* Turin 1941; Claudio Varese, "Teatro, prosa, poesia," in *Il Seicento,* Milan 1967, pp. 543-549; Michelangelo Buonarroti the Younger, *La Fiera. Redazione originaria* (1619), edited by Uberto Limentani, Florence 1984.

LA FIERA
COMMEDIA
DI MICHELAGNOLO BUONARRUOTI
IL GIOVANE
E LA TANCIA
COMMEDIA RUSTICALE DEL MEDESIMO
COLL' ANNOTAZIONI
DELL' ABATE ANTON MARIA SALVINI
GENTILUOMO FIORENTINO

E Lettor delle Lettere Greche nello Studio Fiorentino.

IN FIRENZE MDCCXXVI.
Nella Stamperia di S. A. R. Per li Tartini e Franchi.

Con Licenza de' Superiori.

8. Gregorio Pagani
(Florence 1558 - 1605)
**Portrait of Three Young Men
of the Buonarroti Family**
1600 - 1605
canvas, 37 × 50 cm.
inv. 120

The first mention of this painting dates from an
inventory of 1859, where the author of the work is
indicated as Cristofano Allori and the figures
represented as "nephews of Michelangelo the
poet." Mina Gregori has proposed a convincing
attribution of the work to the late career of Pagani
- that is, to the early Seicento. The style of this
painter, distinguished by compositions with few
figures always studied from life, and characterized
by the use of light, luminous colors, is in fact
recognizable in this pleasant little painting. The
more precise indication of author and date does
not help, however, to identify the three young men,
traditionally considered Sigismondo, Michele, and
Leonardo, nephews of Michelangelo the Younger.

Bibliography: Mina Gregori, "Una breve nota su
Gregorio Pagani," in *Paragone*, 353, 1979, p. 96,
note 7.

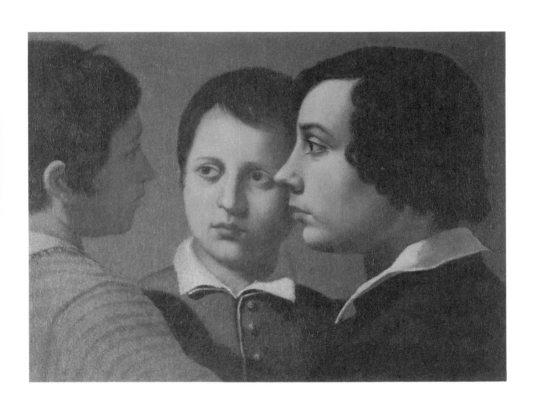

9. Roman copy after Myron
Arm of the Discus Thrower
first century A,D.
marble, 56 × 27.5 cm
inv. 18

The first mention of the existence of this work at the Casa Buonarroti is found in the meticulous late-seventeenth-century inventory known as the "Descrizione Buonarrotiana," to which reference has been made in the present text in several instances: "In the last, small room, on the right hand side of the entrance, is an antique marble arm in the act of throwing a discus, and it is wonderfully made, showing even the muscles and veins." In the late eighteenth century the piece was still in the same place, where it has recently been placed once more; but during the nineteenth century it was displayed in the room containing the reliefs of Michelangelo's youth, where it begged comparison with the *Battle of Centaurs* and the *Madonna of the Stairs.* At that time it was granted the appellative "Greek sculpture."

In the early twentieth century the archaeologist Giulio Emanuele Rizzo recognized in the "arm" of the Casa Buonarroti a fragmentary replica of Myron's *Discus Thrower* similar to the torso discovered in 1906 at Castelporziano. A plaster cast of the arm made immediately thereafter was used by Rizzo to make the *Discus Thrower* for the Museo dei Gessi of the University of Rome, assembled from the best pieces of the known replicas of the famous antique sculpture.

Bibliography: Francis Haskell and Nicholas Penny, *L'antico nella storia del gusto. La seduzione della scultura classica 1500-1900,* Turin 1984 (original edition, New Haven & London 1981), p. 271; *L'archeologia racconta. Lo sport nell'antichità,* exhibition catalogue, Florence 1988, p. 100, no. 46.

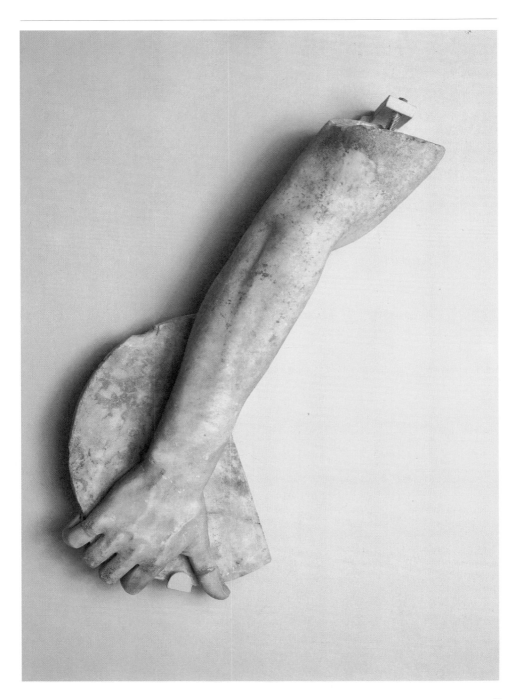

10. Andrea Commodi
(Florence 1560 - 1638)
Self-Portrait
circa 1625
pastel, 335 × 235 mm.
inv. 91

The friendships that linked Michelangelo Buonarroti the Younger to the principal Florentine and Tuscan artists of his time find eloquent testimony in this self-portrait, which was given to the playwright by Andrea Commodi. The work, of high quality and pervaded by a sense of concentrated melancholy, is already mentioned with praise by Filippo Baldinucci, in his *Notizie*, and is the best-preserved and most complete of the numerous pastel works by Commodi mentioned by the sources.

The drawing was executed before 1626, when Michelangelo Buonarroti the Younger sent it for inspection to an unspecified person, perhaps the very young Grand Duke Ferdinand II de' Medici, accompanying it with a sincere evaluation: "I have sent, because it seems very beautiful to me, a head in the portrait-frame of Signor Andrea Commodi by his own hand, a gift he made to me, so that Your Highness might appreciate it as I know you appreciate the man himself." The pastel is therefore a work of Commodi's late career, when the artist, after long stays in Rome and Cortona, had finally returned to Florence.

Bibliography: Gianni Papi, in *Il Seicento fiorentino. Arte a Firenze da Ferdinando I a Cosimo III. Disegno/ Incisione / Scultura / Arti minori*, exhibition catalogue, Florence 1986, p. 252, no. 2.97.

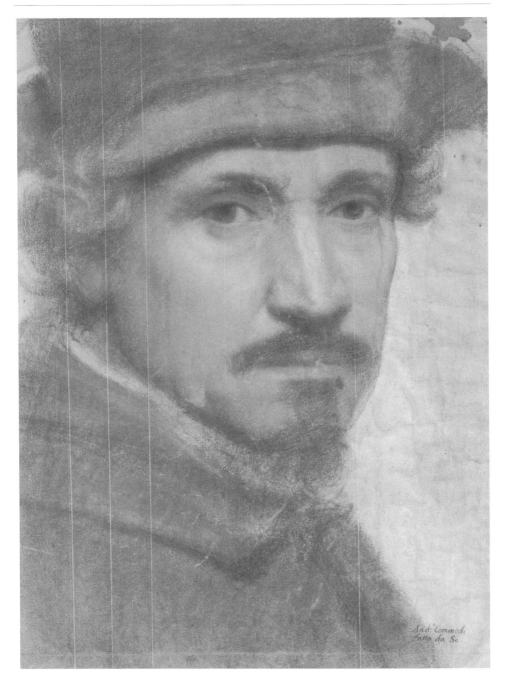

11. Etruscan Cinerary Urn

early first century B.C.
molded terra-cotta with red and brown
painted decorations; 8.5 × 25.5 × 17 cm. (lid),
17.5 × 22.5 × 12 cm. (body)
inv. 13

This urn, which is generically described as coming
from Chiusi, is part of the Etruscan finds brought
together at the Casa Buonarroti by the antiquarian
and erudite, Filippo Buonarroti (1661-1733).
The deceased is represented in a reclining position,
completely covered by a cloak, on the lid. On the
body appears a scene of leave-taking: two cloaked
figures shake hands before a closed door. Behind
each character stands a female demon, in full-length
gown, holding a torch. An inscription indicating
the name of the deceased is painted in red, on the
frame.
The small size and summary decoration of the urn
suggest that it was destined for a person of modest
economic means. The presence of the Etruscan
inscription dates the work to a time before 90 B.C.

Bibliography: Marisa Bonamici, in *Filippo
Buonarroti e la cultura antiquaria sotto gli ultimi
Medici,* catalogue of the exhibition at the Casa
Buonarroti, edited by Daniela Gallo, Florence
1986, p. 74, no. 19.

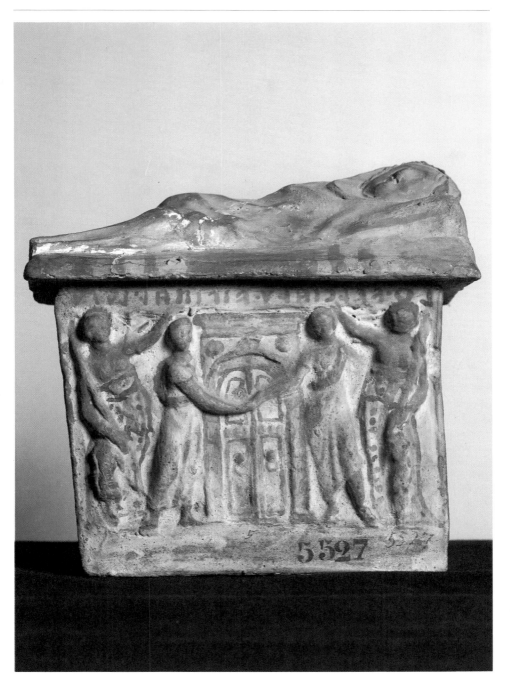

12. Etruscan Balsam Jar

third century B.C.
bronze, height 9.5 cm.
inv. 24

This piece, probably from a workshop located by scholars between Chiusi and Orvieto, like the urn classified here as number eleven, was acquired for the Buonarroti collections by the antiquarian and erudite, Filippo Buonarroti (1661-1733). It is a balsam jar in the shape of a female head, with the hair set in locks and gathered together at the top. In place of the chignon there is a circular aperture that must have borne a lid, now lost.

The balsam jar exemplifies that sort of luxury objects which were based to some extent on rare Greek models, but were peculiarly Etruscan with regard to their form and the use, which was twofold, the jar having a place both on women's beauty-tables and in burial treasures.

Bibliography: Marisa Bonamici, in *Filippo Buonarroti e la cultura antiquaria sotto gli ultimi Medici,* catalogue of the exhibition at the Casa Buonarroti, edited by Daniela Gallo, Florence 1986, pp. 79-80, no. 31; *Les Etrusques et l'Europe,* exhibition catalogue, Milan 1992, p. 382.

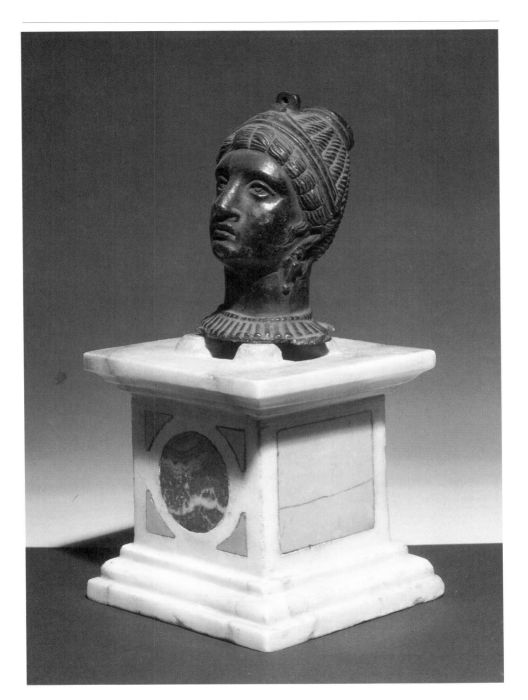

13. Florentine artist of the late seventeenth
and early eighteenth century
Homage of the Arts to Michelangelo
canvas, 64 × 52 cm.
inv. Gallerie 1890, no. 4411

This canvas came to the Casa Buonarroti in 1951,
on deposit from the Florentine Galleries, in whose
inventories it is mentioned for the first time in 1880.
It is a piece of graceful workmanship by an artist of
the post-Cortonesque Florentine current with a
style similar to that of Simone Pignoni (1611-1698).
Three female figures and a small winged genius,
personifications of the arts, render homage to
Michelangelo, whose bust (on the right) rests on a
column bearing a quotation from Ariosto, *Michel
più che mortale Angel divino* ('Michael more than
mortal divine angel': *Orlando Furioso*, XXXIII, 2).
The small genius bears the palette, emblematic of
Painting; below, on the steps, a cartouche with a
floorplan symbolizes Architecture; compasses
indicate Sculpture; and an open book bears figure
drawings.
Tolnay recognizes a representation "of the
landscape of his native Caprese" in the painting's
background, and in fact one seems to glimpse there
what Michelangelo himself, speaking with Vasari,
had defined the "thinness of the air" of the
mountains near Arezzo.

Bibliography: Charles de Tolnay, *L'omaggio a
Michelangelo di Albrecht Dürer,* Rome 1972, p. 10.

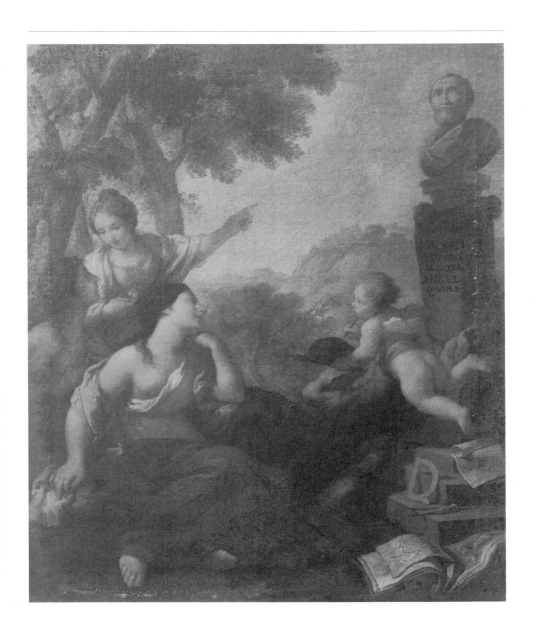

14. Michelangelo
Study for a Head, for the Madonna
of the Doni Tondo
circa 1504
red chalk, 199 × 172 mm.
inv. 1 F

This is one of Michelangelo's first important drawings in *sanguigna* (red chalk), almost certainly executed from a male model. The supposition has been advanced that this splendid drawing might be a study for the head of the prophet Jonah in the Sistine Chapel; but this hypothesis appears to be contradicted by comparison with Michelangelo's drawings for the Sistine Ceiling. It is much more probable that the drawing is a study for the head of the Madonna in the *Doni Tondo*, the panel painting representing the Holy Family preserved at the Uffizi Gallery and made by Michelangelo, probably in connection with the wedding of Agnolo Doni and Maddalena Strozzi, in 1504.

Bibliografia: Michael Hirst, *Michel-Ange dessinateur,* exhibition catalogue, Paris 1989, p. 30, no.10.

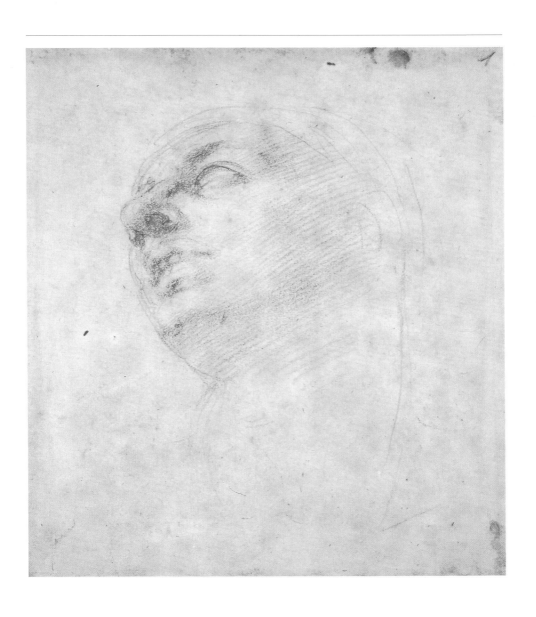

15. Michelangelo
Letter to His Brother Buonarroto
1511
pen and ink, 145 × 218 mm.
inv. 63

This letter of 18 January 1511 was written by Michelangelo, in Rome, to his favorite brother, Buonarroto, in Florence. The back of the page, where the artist wrote the address, also bears a note by Buonarroto acknowledging receipt of the letter. The content has to do with financial matters: Michelangelo asks Buonarroto to transfer to his account the sum of 228 *ducati larghi,* which Buonarroto should have received in a previous letter of exchange sent to him by Michelangelo.

Michelangelo dated the letter 1510 because, although he was in Rome, he made use of the Florentine calendar, according to which the new year began "ab Incarnatione," that is, on 25 March. It is interesting to notice that Michelangelo, although addressing a family member, confirms in his signature that he is a sculptor ("Michelagniolo schultore"), during the years when he was frescoing the ceiling of the Sistine Chapel and was therefore engaged in the greatest pictorial undertaking of his life.

Bibliography: Charles De Tolnay, "Due lettere originali autografe di Michelangelo. Recenti acquisizioni delle collezioni della Casa Buonarroti," in *Scritti di storia dell'arte in onore di Ugo Procacci,* II, Milano 1974, pp. 365-369.

B uonarroto io ti mandai sabato una lettera di babbo di duccio uetto cto
duchati larghi sette l ai ricevuta una e fatteli dare e portagli
allo spedalingo e fagli mettere a mio conto sette no ai auuto la d
tta lettera d questa fara lasechonda de decti duchati no gliauen
do auuti a la prima fa dauergli a dn auiso Adi dicocto di gennai
mille cinquo cento dieci

Michelagniolo Schultore
i roma

16. Michelangelo
**Sketches of Blocks of Marble for the Tomb
of Julius II, with Measurements in the Artist's
Handwriting**
circa 1516
pen and ink, 202 × 305 mm.
inv. 67 A

These sketches probably belonged to Michelangelo's notebooks, of which only a few pages survive. Although a great many sketches of this kind, regarding various works by the artist, are preserved in the Buonarroti Archive, the Home's Drawing Collection contains only three such pieces (in addition to 67 A, in this exhibition, 68 A and 74 A), all connected with the preparatory work for the tomb of Pope Julius II. The documentary value of these papers, which provide evidence of Michelangelo's custom of jotting down quick sketches accompanied by very precise indications of measurements (which in this case refer to the size and forms of the marble blocks the artist was thinking of using) for his stonecutters, has been underscored on more than one occasion.

Bibliography: Paola Barocchi, *Michelangelo e la sua scuola. I disegni di Casa Buonarroti e degli Uffizi,* Florence 1962, pp. 74-75, no. 53

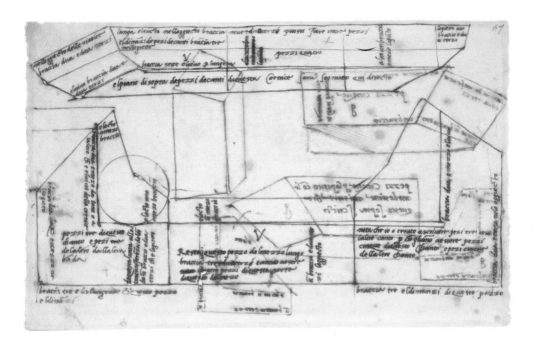

17. Michelangelo
**Two Studies of a Ciborium and One
of a Sarcophagus**
1518
black chalk, 275 × 205 mm.
inv. 110 A *recto*

The *verso* of this page contains a long autographic "memoir" (cf. cat. 22), in which Michelangelo sums up, with regard to the period of time ranging from 5 December 1516 to 25 February 1518, the tormented events connected with the façade of the church of San Lorenzo in Florence (a façade which, as is known, was never executed). Thode, Tolnay, and Dussler take this note as evidence for dating the three studies on the *recto* to 1518 and for proposing a relation between these studies and the designs for ornaments that Pier Soderini had asked of the artist, in 1518, for an altar in the church of San Silvestro in Capite in Rome. Stylistic motivations second this chronology: the artist's mark in these sketches, which Paola Barocchi defines "lively but still timid," and the archaicizing structures rule out later datings.

Bibliography: Paola Barocchi, *Michelangelo e la sua scuola. I disegni di Casa Buonarroti e degli Uffizi,* Florence 1962, pp. 49-51, no. 36.

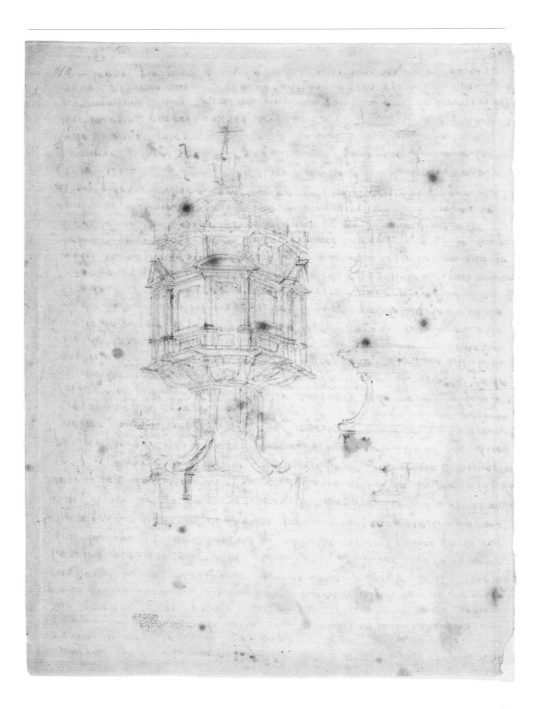

18. Michelangelo
**Three Different Lists of Foods Described
with Ideograms**
1518
pen and ink, 213 × 145 cm.
Buonarroti Archive, vol. X, f. 578 *verso*

Michelangelo traced these three menus for three
meals of varying size while he was quarrying marble
in Pietrasanta, on the back of a letter sent to him on
18 March 1518 by Bernardo Nicolini: in other
words, he used the first sheet of paper he could get
his hands on, as was often his custom. The grocery
list corresponds to a scrupulous intention to
register the expenses and events of his day-to-day
life; it offers proof of Michelangelo's frugal
customs, pointed out and praised by his
biographers. The note in this case might have been
meant for the sculptor Pietro Urbano, an assistant
of the artist: Michelangelo's administrative papers
from this period, in fact, include notes in Pietro
Urbano's handwriting regarding everyday
expenses.
On the other hand - and the first to point this out
was Tolnay when he published the sketches on this
page - the power and confidence of the mark make
these utilitarian notes a characteristic manifestation
of the genius of a great artist.

Bibliography: Lucilla Bardeschi Ciulich, *Costanza
ed evoluzione nella scrittura di Michelangelo,*
catalogue of the exhibition at the Casa Buonarroti,
Florence 1989, pp. 28-29, no. 10.

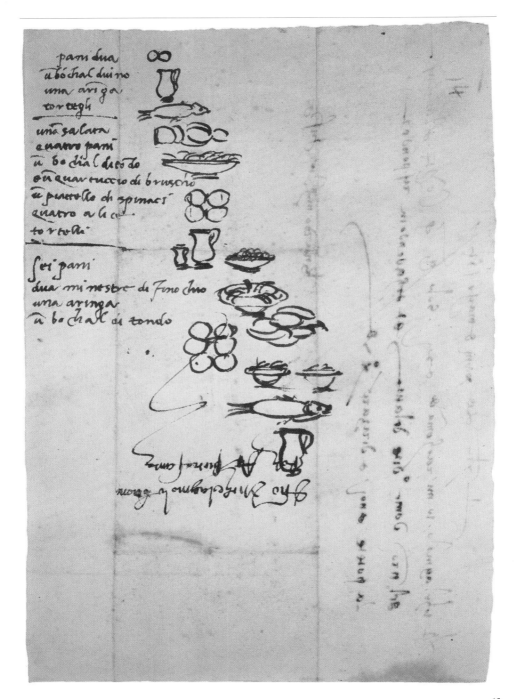

pani dua
ū bóchal di vino
una aringa
tortegli

una salata
e nuovo pani
ū bochal di deto do
on quartuccio di bruscio
ū piatello di spinaci
quatro a le co...
tortelli

sei pani
dua minestre di finochio
una aringa
ū bochal di tondo

19. Michelangelo
Three Fountain Designs
1521
pen and ink, 118 × 163 mm.
inv. 73 A

In connection with these three studies reference may be made to two letters to Michelangelo, written in 1521, in which the artist, then in Carrara, is asked to oversee the quarrying of the marble for a "vase" and a "dish" (definitions referring to parts of a fountain). On the other hand the quick, lively mark, while not permitting precise references, reveals solutions devoid of the erudition of the late Quattrocento, so that some have seen here presages even of the baroque fountains of Piazza Colonna and Piazza del Popolo in Rome.

Bibliography: Paola Barocchi, *Michelangelo e la sua scuola. I disegni di Casa Buonarroti e degli Uffizi,* Florence 1962, pp. 122-123, no. 97.

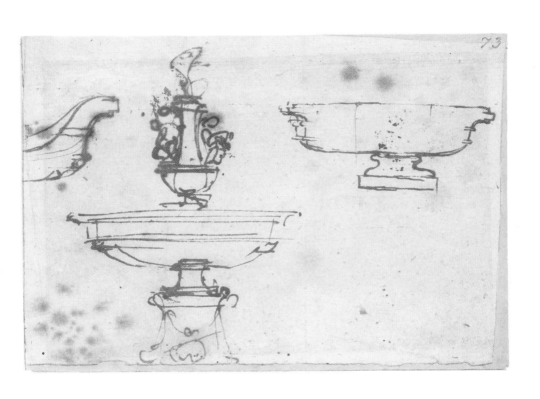

20. Michelangelo
Bases of Pilasters for the New Sacristy
circa 1520-1525
red chalk, 282 × 213 mm.
inv. 9 A

This drawing is very important for the reconstruction of the events surrounding the New Sacristy of San Lorenzo in Florence, where Michelangelo, at the request of Cardinal Giulio dei Medici (who became Pope Clement VII in 1523), was to make the tombs of four members of the Medici family. These bases of pilasters refer to the project for the Sacristy's interior. On the back of the page, cut out and originally joined to another drawing of the Casa Buonarroti Collection (inv. 10 A), appears part of the plan of the convent of San Lorenzo.

Bibliography: Paola Barocchi, *Michelangelo e la sua scuola. I disegni di Casa Buonarroti e degli Uffizi,* Florence 1962, p. 86, no. 62.

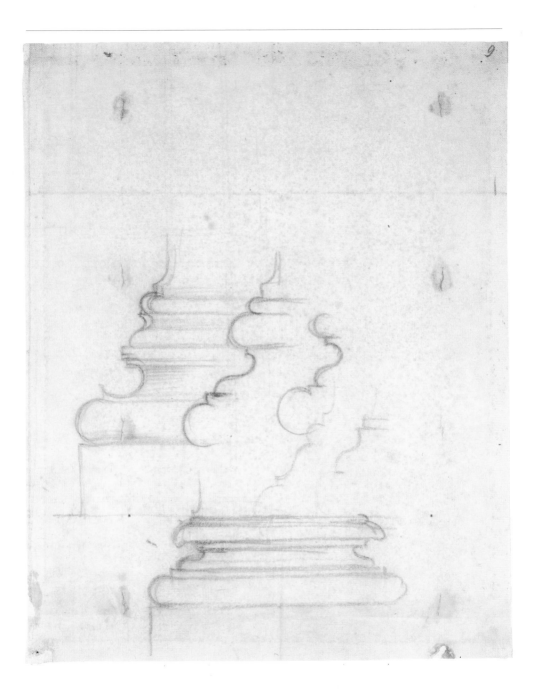

21. Michelangelo
Study of Legs
circa 1524-1525
pen and ink, 149 × 193 mm.
inv. 44 F

This drawing dates from the years in which Michelangelo was engaged in the complex sculptural project for the New Sacristy of San Lorenzo in Florence. The realization of a large number of statues and an immense decorative program was accompanied by an intense exercise of drawing, chiefly addressed to the study of the human figure. Many of the drawings from this period are not strictly related to figures of the Sacristy, but, as in the case of this page, give evidence of a supreme skill in rendering the human body from life - a skill capable of suggesting impressions of strength and softness, tension and abandon. Perpendicular to the figuration, and unrelated to it, runs the inscription "mi soviene" ('I recall') in Michelangelo's handwriting.

Bibliography: Michael Hirst, *Michel-Ange dessinateur,* exhibition catalogue, Paris 1989, pp. 66-67, no. 30.

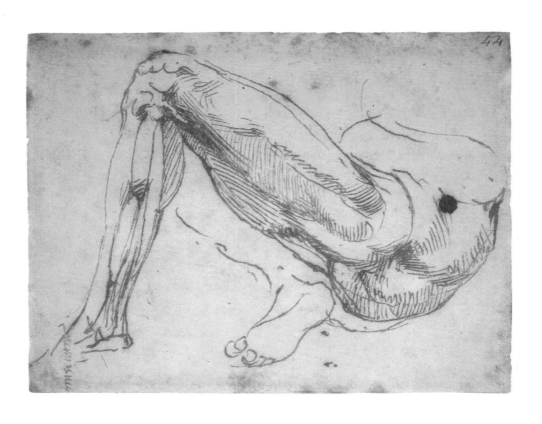

22. Michelangelo
"Memoir" of 16 July 1525
1525
pen and ink , 300 × 220 mm.
inv. 695

The expression "memoirs" is used here to indicate
that set of papers in Michelangelo's handwriting
which includes his administrative notes. The
"memoirs" were published for the first time by
Gaetano Milanesi in 1875 and subsequently, in a
critical edition, by Lucilla Bardeschi Ciulich and
Paola Barocchi in 1970. This beautifully written
page, given to the Casa Buonarroti in 1984 by Irene
Kretschmann-Rousset, contains annotations
concerning the revenue (from wine, grain, and oil)
provided by the farm that Michelangelo had
acquired three years earlier at Settignano, near
Florence.

Bibliografia: Lucilla Bardeschi Ciulich, *Costanza ed
evoluzione nella scrittura di Michelangelo,* catalogue
of the exhibition at the Casa Buonarroti, Florence
1989, pp. 36-37, no. 16.

Ricordo oggi questo dì sedici di luglio 1525 dellentrate de poderi di scoltigniano
di quello ch tiene lapo e di quello ch tiene elbalena quello ch anno fructato
da quatro anni in qua e de patti ch anno auuti insino a ora

El podere che tiene lapo cioè questo solo ch io chompai daguido diporcello ha facto
da duanni adrieto pensiono inocto anni ha facto intucto arragione di ueta barili
di uino lanno e digrano arragione di quaranta staia lanno e dolio ha facto
l uno anno pla lero tre quatro barii uenti barili insino aduanni fa a se
cho lanno un sacho di fichi e mandorle dua staia

E da duanni inqua ha facto decto podere quaranta sei barili di uino l uno anno
e questo trenta octo e ha facto questo anno decto sessantaocto barili dolio e lanno
passato no fece niente del grano da duanni in qua e lprimo dec lanno passato
me fece staia quaranta e questo anno decto anchora circa quaranta
certe terre ch furono di bernardo barbiere e delgosso ch tiene ano chon decto
capo fanno intorno a staia digrano luno anno pla lero cinsei barili di uino e doli
sta cinquattorduci barili luno anno pla lero e questo anno ma facto uenti octo barili
e patti ch olii mecho ouero ch auuti insino a ora ch lo douicho mio padre sono que
sti ch gli abi a fare ch quaranta propagine lanno e ch gli abi a dare uinpaio di
chapponi lanno e cinque serue duoua e uenti braccia di fossa e a portar e
sei some lanno a fioreze anno piacimeto elluame ch sitoglie infonerze io le
apagare tucto quello ch sitoglie lasse lo apagare me zzo

Decto capo a le terre dagrano di decti poderi ha facto lanno mio padre e danne di decto
fitto staia quaranta digrano lanno tucto e questo fa a mezo

23. Michelangelo
**Plan of the "Small Library" of the Laurentian
Library**
1525
pen, ink and wash, 212 × 280 cm.
inv. 80 A

The "small" or "secret library" was commissioned
by Pope Clement VII from Michelangelo in 1525
and was to contain the more valuable volumes. In
Michelangelo's design it occupied the spaces,
previously intended for the chapel, in which the
main hall of the Laurentian Library was to end.
But this room, conceived as a sort of companion
piece to the atrium of the Library, was never built.
On this page, and on another that is also part of the
Collection of the Casa Buonarroti (inv. 79 A), one
may follow the development of Michelangelo's
design, characterized by the gradual increase in
articulations of the walls, by means of columns,
niches, and pilasters.
Some of the notes in the artist's handwriting
provide suggestions concerning the lighting of the
"small library"; others allude to instructions for
the purchase of a house, communicated to
Michelangelo by the pope.

Bibliography: *Michelangelo e la sua scuola. I disegni
di Casa Buonarroti e degli Uffizi,* Florence 1962,
pp. 111-112, no. 88.

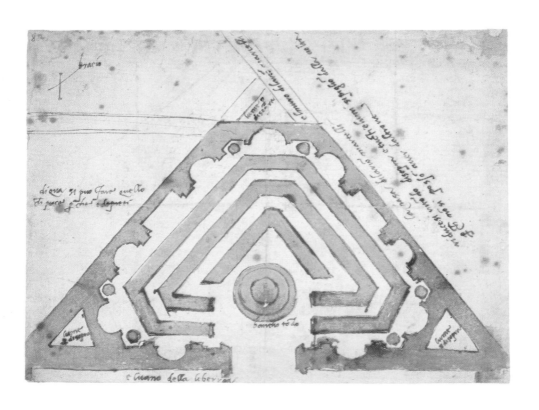

24. Michelangelo
Study for a Reading Desk for the Laurentian Library
circa 1525
red chalk, pen and ink, 160 × 201 mm.

Clement VII carefully followed every detail of the decoration of the Laurentian Library - to the point that, through one of Michelangelo's correspondents, he inquired in 1524 into the form of the desks for the reading room. This drawing reflects one of Michelangelo's first ideas in this regard. The human form summarily sketched in on the right seems intended to specify how much space was to be destined to the reader.

The Laurentian desks were executed beginning in 1534; today they still bear the decorations added by the craftsmen who fashioned them. The drawings of an arm and leg in red chalk do not seem autographic.

Bibliography: Michael Hirst, *Michel-Ange dessinateur,* exhibition catalogue, Paris 1989, pp. 80-81, no. 33.

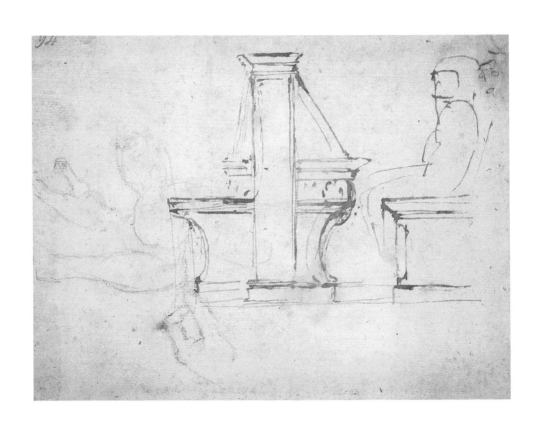

25. Michelangelo
Studies for Fortifications of the Porta al Prato d'Ognissanti
circa 1529-1530
red chalk, pen and ink, and brown washes,
388 × 558 mm.
inv. 14 A

26. Michelangelo
Studies for Fortifications of the Porta al Prato d'Ognissanti and Sketches of Figures
circa 1529-1530
red chalk, black chalk, pen and ink, and brown washes, 362 x 407 mm.
inv. 27 A

After the Medici were expelled from Florence, on 17 May 1527, Michelangelo, summoned by the Florentine Republic to design the city's fortifications, made a series of proposals for the defense of the gates in the walls. Because of their complexity and novelty, these proposals either were not implemented or were carried out only in part, the parts being no longer extant. Drawings such as these for the fortification of the Porta al Prato d'Ognissanti demonstrate a marked functionality and an originality fully coherent with Michelangelo's other architectural works of the same period.

Bibliography: Pietro Marani, *Disegni di fortificazioni da Leonardo a Michelangelo,* catalogue of the exhibition at the Casa Buonarroti, Florence 1984, pp. 80-82, nos. 54 and 55.

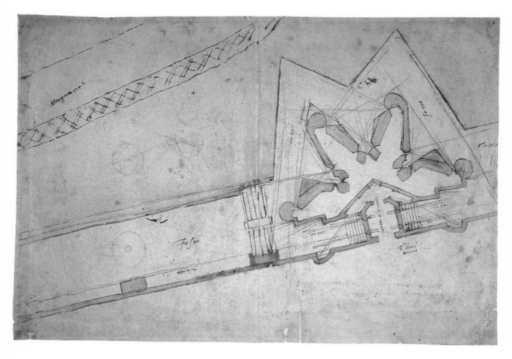

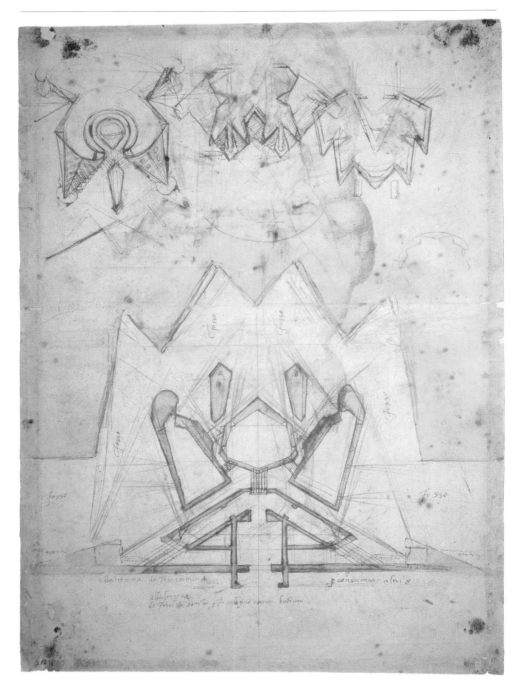

27. Michelangelo
Sacrifice of Isaac
circa 1530-1535
black chalk, pen and ink, and red chalk,
421 × 296 mm.
inv. 70 F

This drawing is among the more famous pieces in
the Collection of the Casa Buonarroti. Berenson
defined it as "one of the most interesting of
Michelangelo's mature sketches," going on to say,
"black chalk is used with a master's freedom, every
touch telling, no fumbling, no indecision, nothing
over-elaborated and nothing omitted."
It is not known what project this page, which is
considered autographic by all except Baumgart and
Panofsky (who unsuccessfully proposed the name
of Daniele da Volterra), was destined for. On the
basis of its inclusive mark, which is fully readable
notwithstanding a few later revisions, the drawing
reveals a mature phase and seems to foreshadow
the more tormented movement of the *Last
Judgment* of the Sistine Chapel. The date proposed
here is based on these stylistic motivations.

Bibliography: Paola Barocchi, *Michelangelo e la sua
scuola. I disegni di Casa Buonarroti e degli Uffizi,*
Florence 1962, pp. 174-175, no. 140.

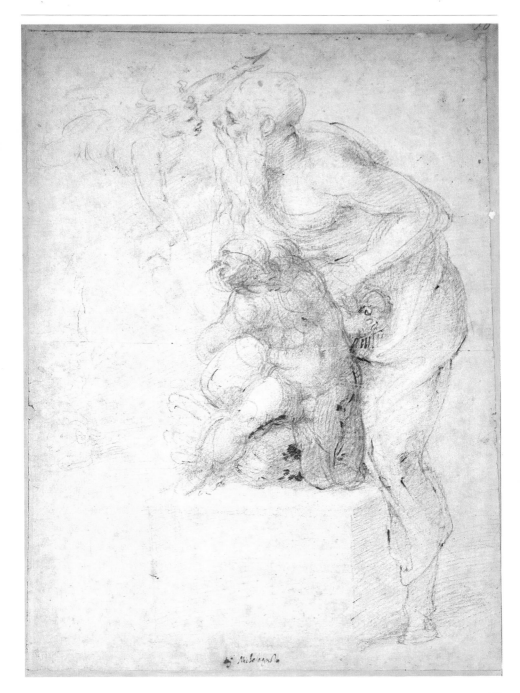

28. Michelangelo
Study for a Christ in Limbo
circa 1530-1535
red and black chalk, 163 × 149 mm.
inv. 35 F

This drawing is one of the last signs of the relationship that existed between Michelangelo and the Venetian painter Sebastiano del Piombo, who came to Rome at the beginning of the second decade of the Cinquecento. On more than one occasion Michelangelo provided Sebastiano with drawings to guide him in the making of his paintings; examples of this generous aid include the famous *Flagellation* in the Borgherini Chapel in San Pietro in Montorio in Rome or the *Resurrection of Lazarus* preserved in the National Gallery in London.
Michelangelo made a red-chalk sketch of a dramatic Christ in Limbo that Sebastiano used for a work of his on the same subject made in the early thirties and presently exhibited at the Prado. In the painting, however, the scene is more subdued; the tumultuous power that characterizes the drawing and that may well be compared to the early designs for the *Last Judgment,* vanishes.

Bibliography: Michael Hirst, *Sebastiano del Piombo,* Oxford 1981, pp. 129-130.

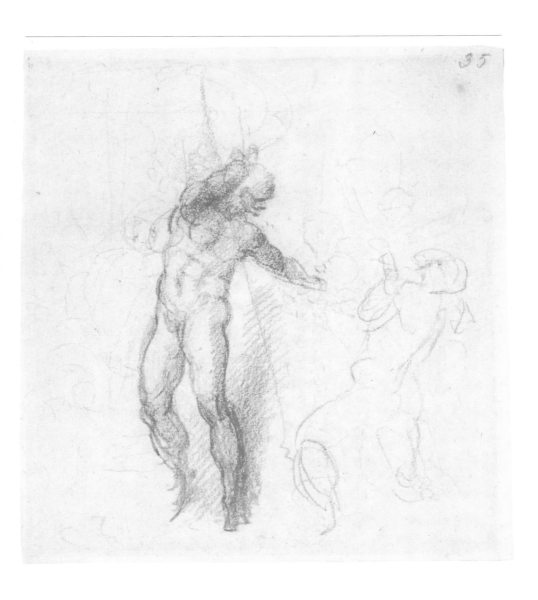

29. Michelangelo
Overall Study for the Last Judgment
circa 1534
black charcoal, red chalk, 416 × 297 mm.
inv. 65 F

This is the most important extant evidence of the
design of the *Last Judgment* proposed to
Michelangelo by Pope Clement VII in 1533 and
executed from November 1536 to October 1541.
The drawing refers to the first phase of the
conception of the work, when the artist still
intended to maintain, on the wall to be frescoed,
Perugino's altarpiece representing the Assumption
of the Virgin, at the bottom and, at the top, the two
lunettes with the Ancestors of Christ which he
himself had executed when working on the ceiling.
Later Michelangelo abandoned this idea and
represented almost all the figures differently, with
the exception of Christ and a few other characters.

Bibliography: Michael Hirst, *Michel-Ange
dessinateur,* exhibition catalogue, Paris 1989,
pp. 127-129, no. 51.

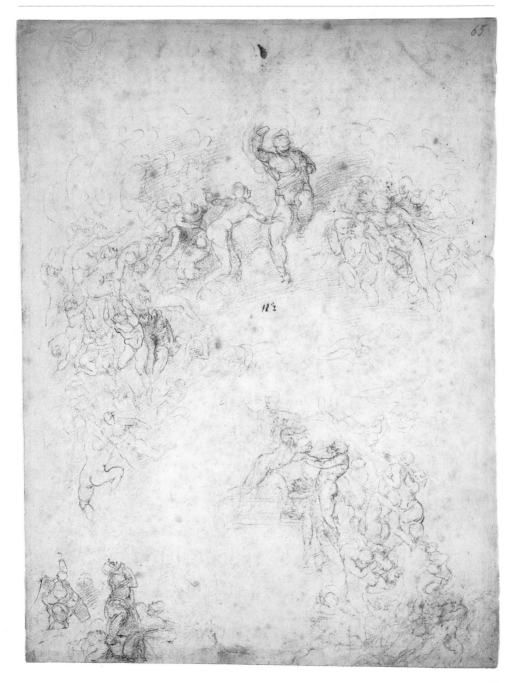

112

30. Michelangelo
Study for Porta Pia
1561
black chalk and wash, 398 × 268 mm.
inv. 73 A bis

This is a study for the monumental gate at the end of Via Venti Settembre in Rome. The decision to entrust the construction of Porta Pia to Michelangelo, who was eighty-six years old at the time, was made by Pope Pius IV in 1561. The artist worked hard on this last commission, for which there are numerous drawings, small and large (as is the case of this piece). According to Vasari, Michelangelo submitted to the pope three different solutions for the gate, and the least expensive was chosen.

A convincing hypothesis has been advanced according to which Michelangelo began this page with the intention of making a finished drawing to present to the pope; but the composition remained unfinished, for unknown reasons. Later designs for the gate, also preserved at the Casa Buonarroti, present equally expressive solutions characterized by an increasing use of brushwork, in the pursuit of extraordinary chiaroscuro effects.

Bibliography: Michael Hirst, *Michel-Ange dessinateur,* exhibition catalogue, Paris 1989, pp. 159-160.

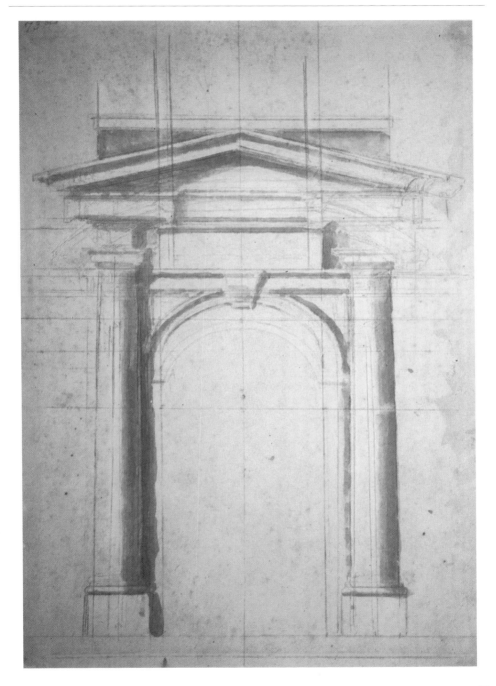

Selected Bibliography

Paola Barocchi, *Michelangelo e la sua scuola. I disegni di Casa Buonarroti e degli Uffizi,* Florence 1962.

Paola Barocchi, *Michelangelo e la sua scuola. I disegni dell'Archivio Buonarroti,* Florence 1964.

Ugo Procacci, *La Casa Buonarroti a Firenze,* Milan 1965.

Charles de Tolnay, *Casa Buonarroti,* Florence 1970.

Charles de Tolnay, *Corpus dei disegni di Michelangelo,* Novara 1975-1980.

Adriaan W. Vliegenthart, *La Galleria Buonarroti, Michelangelo e Michelangelo il Giovane,* Florence 1976, original edition Amsterdam 1969.

Paola Squellati Brizio, "Casa Buonarroti," in *La Città degli Uffizi,* catalogue of the exhibition, Florence 1982, pp. 177-192.

Disegni di fortificazioni da Leonardo a Michelangelo, catalogue of the exhibition at the Casa Buonarroti, edited by Pietro Marani, Florence 1984.

Michelangelo e i maestri del Quattrocento, catalogue of the exhibition at the Casa Buonarroti, edited by Carlo Sisi, Florence 1985.

Luciano Berti, *Michelangelo. I disegni di Casa Buonarroti,* Florence 1985.

Filippo Buonarroti e la cultura antiquaria sotto gli ultimi Medici, catalogue of the exhibition at the Casa Buonarroti, edited by Daniela Gallo, Florence 1986.

Casa Buonarroti, edited by Giovanna Ragionieri, with a historical note by Vittorio Vasarri, Florence 1987.

Michelangelo. Studi di antichità dal Codice Coner, edited by Giovanni Agosti and Vincenzo Farinella, Turin 1987.

Michelangelo e l'arte classica, catalogue of the exhibition at the Casa Buonarroti, edited by Giovanni Agosti and Vincenzo Farinella, 1987.

Michelangelo architetto. La facciata di San Lorenzo e la cupola di San Pietro, catalogue of the exhibition at the Casa Buonarroti, edited by Henry Millon and Craig Hugh Smyth, Milan 1988.

Michael Hirst, *Michelangelo and his Drawings,* New Haven & London 1988.

Le due Cleopatre e le "teste divine" di Michelangelo, catalogue of the exhibition at the Casa Buonarroti, Florence 1989.

Michel-Ange dessinateur, exhibition catalogue edited by Michael Hirst, Paris & Milan 1989.

Costanza ed evoluzione nella scrittura di Michelangelo, catalogue of the exhibition at the Casa Buonarroti, edited by Lucilla Bardeschi Ciulich, Florence 1989.

Pittura di luce. Giovanni di Francesco e l'arte fiorentina di metà Quattrocento, catalogue of the exhibition at the Casa Buonarroti, edited by Luciano Bellosi, Milan 1990.

Artemisia, catalogue of the exhibition at the Casa Buonarroti, edited by Roberto Contini and Gianni Papi, Rome 1991.

Il Giardino di San Marco. Maestri e compagni del giovane Michelangelo, catalogue of the exhibition at the Casa Buonarroti, edited by Paola Barocchi, Milan 1992.

Michelangelo Drawings, proceedings of the meeting, Washington, 7-8 October 1988, edited by Craig H. Smyth, Washington 1992.

Casa Buonarroti - I disegni di Michelangelo, Milan-Florence 1993.

Casa Buonarroti - Il Museo, Milan-Florence 1993.

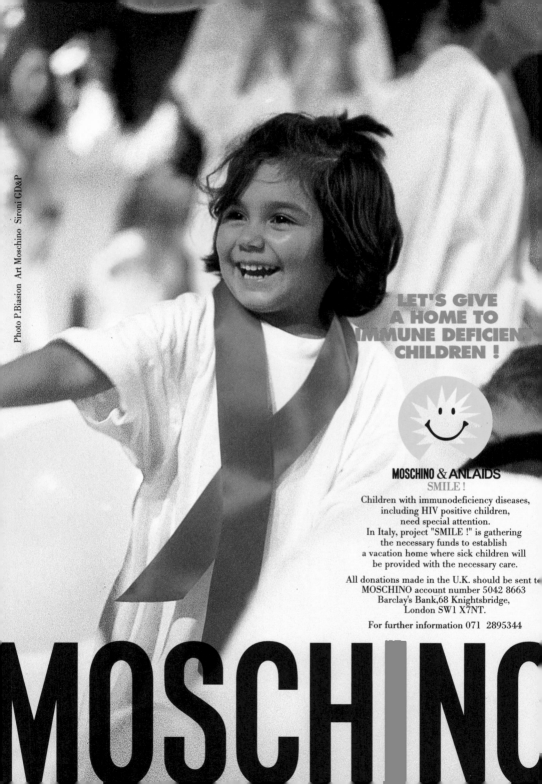

Moschino is sponsoring, in collaboration with the Lombardy section of ANLAIDS, Italy's association for the fight against AIDS, a fund-raising compaign for the refurbishing of a holiday home for children suffering from severe chronic illnesses who lack adequate family support, including HIV positive children. The latter now represents one of our most urgent problems today: HIV positive children are often children of parents who are themselves ill, lack adequate family support, or are deceased.

AIDS in children has assumed worrying proportions in Italy, where numbers exceed those in other European countries and the United States. The complex needs the disease gives rise to, which are psychological, human and social as well as medical, now require urgent and adequate attention. The new MOSCHINO / ANLAIDS foundation sees this pioneering holiday home as the first in a series of similar initiatives throughout Italy that will increase the number of centres for children by drawing on funds donated by all those who wish to make a real contribution towards fighting the disease or alleviating the suffering it causes.

The aim is to offer sick children a holiday home open all year round in a caring environment that offers them life-enhancing opportunities to socialise with other children and live in contact with nature.

Obviously, the children will be given full professional support: a psychologist, a social worker, a doctor, their own mothers and volunteers trained in helping children.

The home will meet all current legal and medical standards as well as the needs of its future patient, so it will have to be fully furnished and equipped for this purpose and conform to legal safety requirements regarding size, layout and materials. It will be situated in an area with a suitable climate (lakeside, hill or mountain) which is easily accessible by public transport (railway or coach) from all northern Italian regions and near a town with a medical centre.

All donations made in the U.K. should be sent to Moschino
Account number 5042 8663 Barclays Bank, 68 Knightsbridge, London SW1 X7NT

Fiore Crespi
President ANLAIDS Lombardia Region
via Mosé Bianchi 94
20149 Milano Italy

Prof. Mauro Moroni
Department of Infective Diseases at Milan University
Vice President ANLAIDS Lombardia Region